DESERTED PLACES

ALL RIGHTS RESERVED © EMILIE MALMROS
PUBLISHER E&M PUBLISHING
2013

THE LAST WATCH

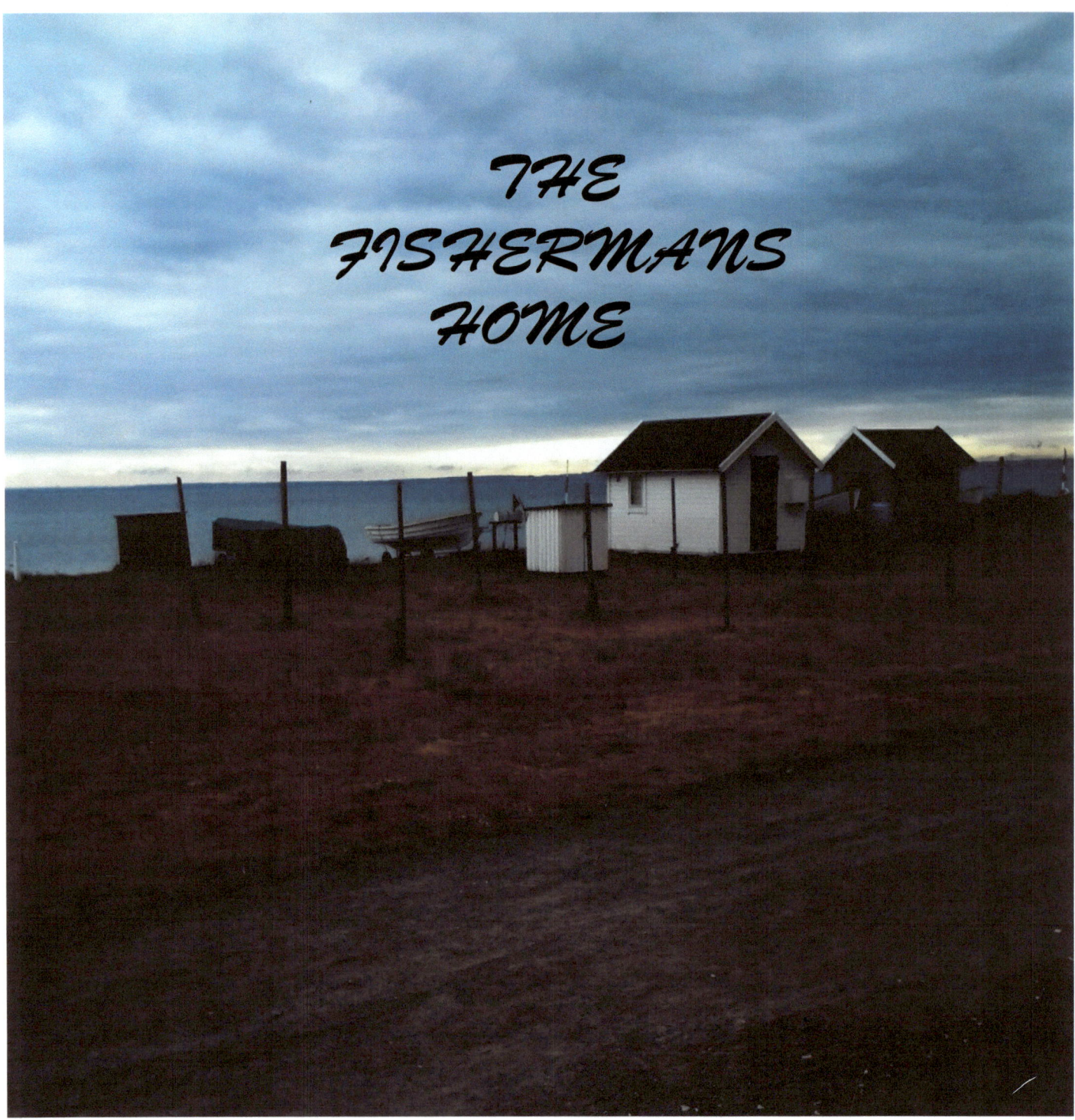

AFTER DEATH

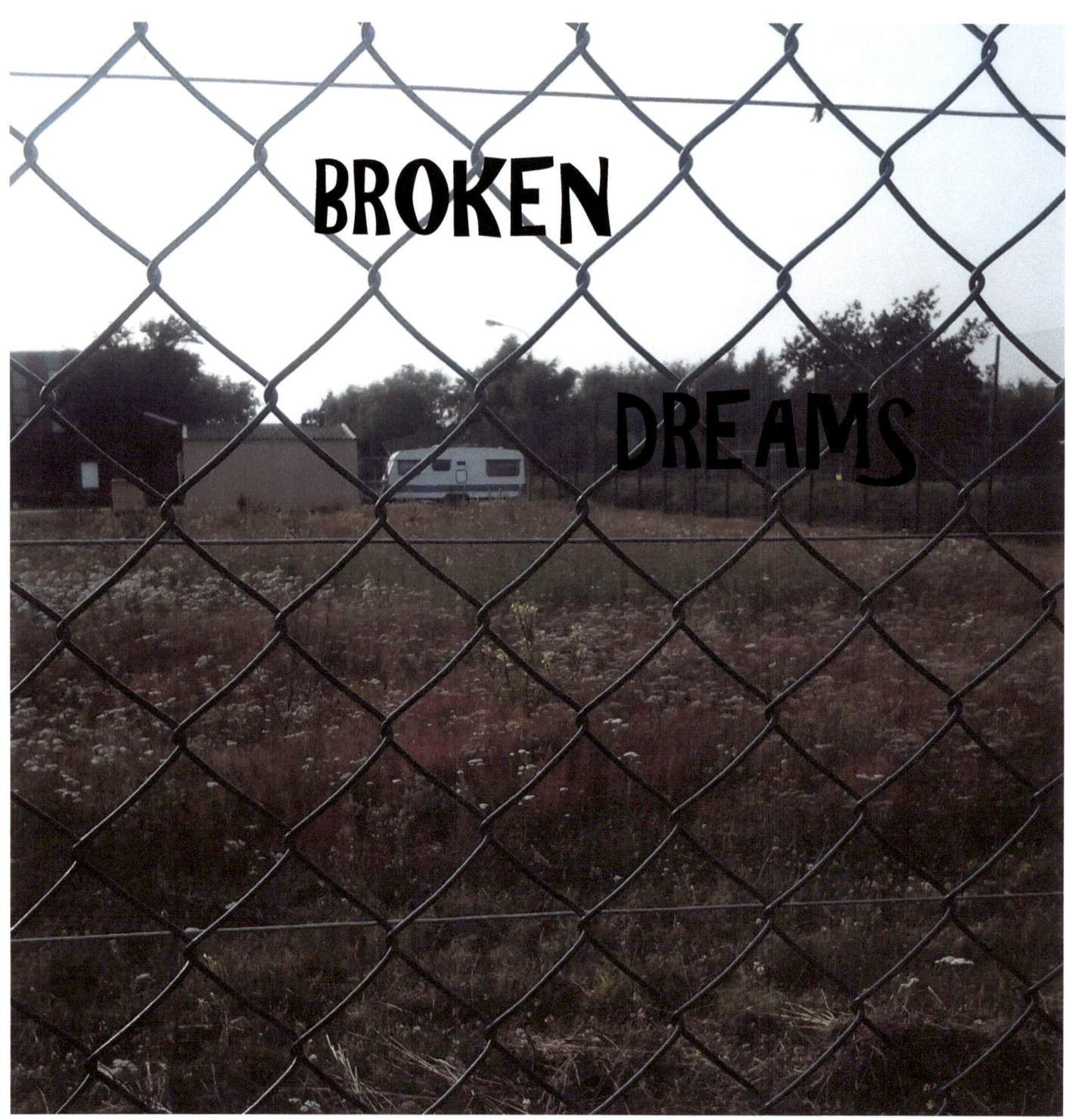

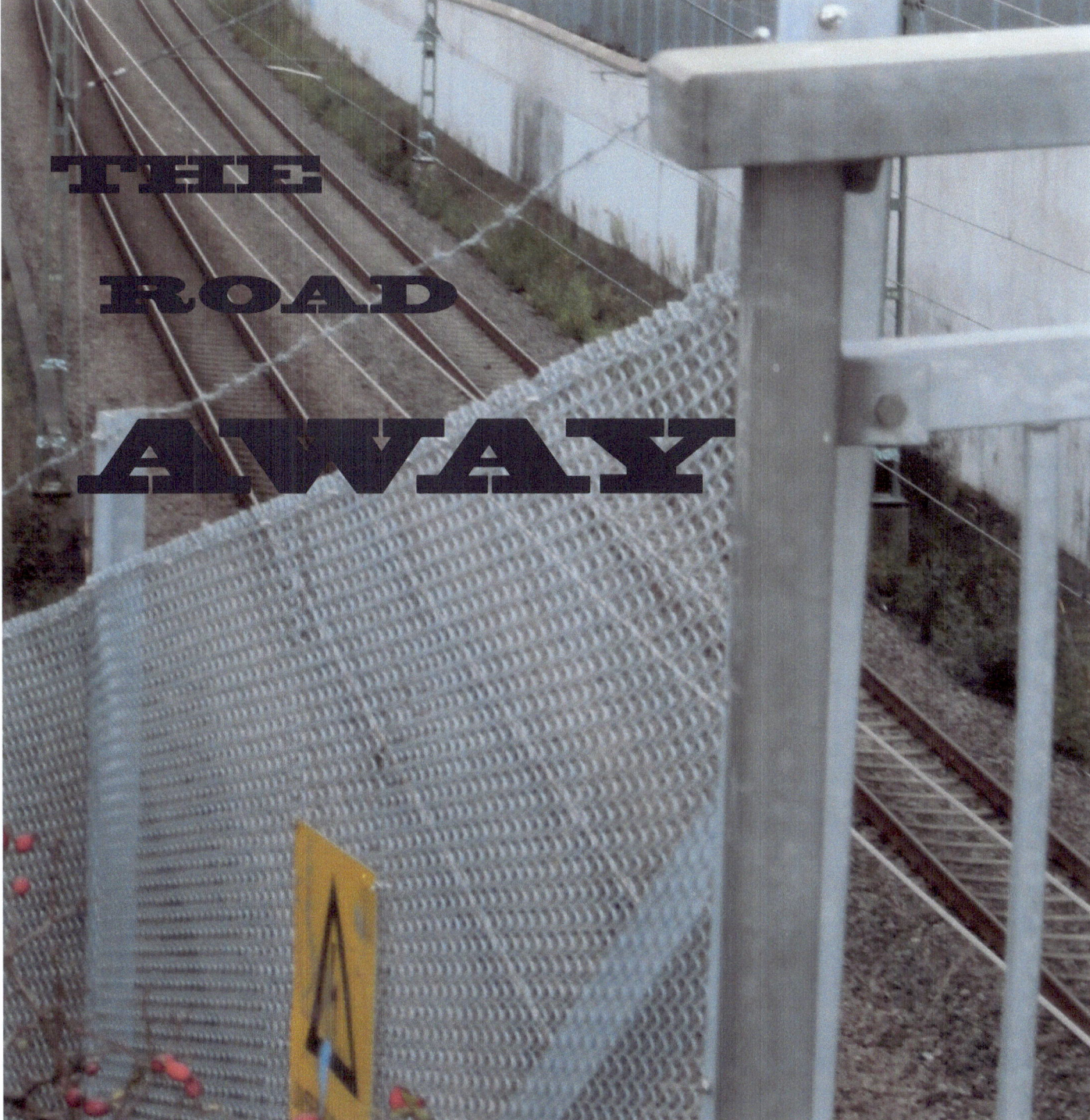

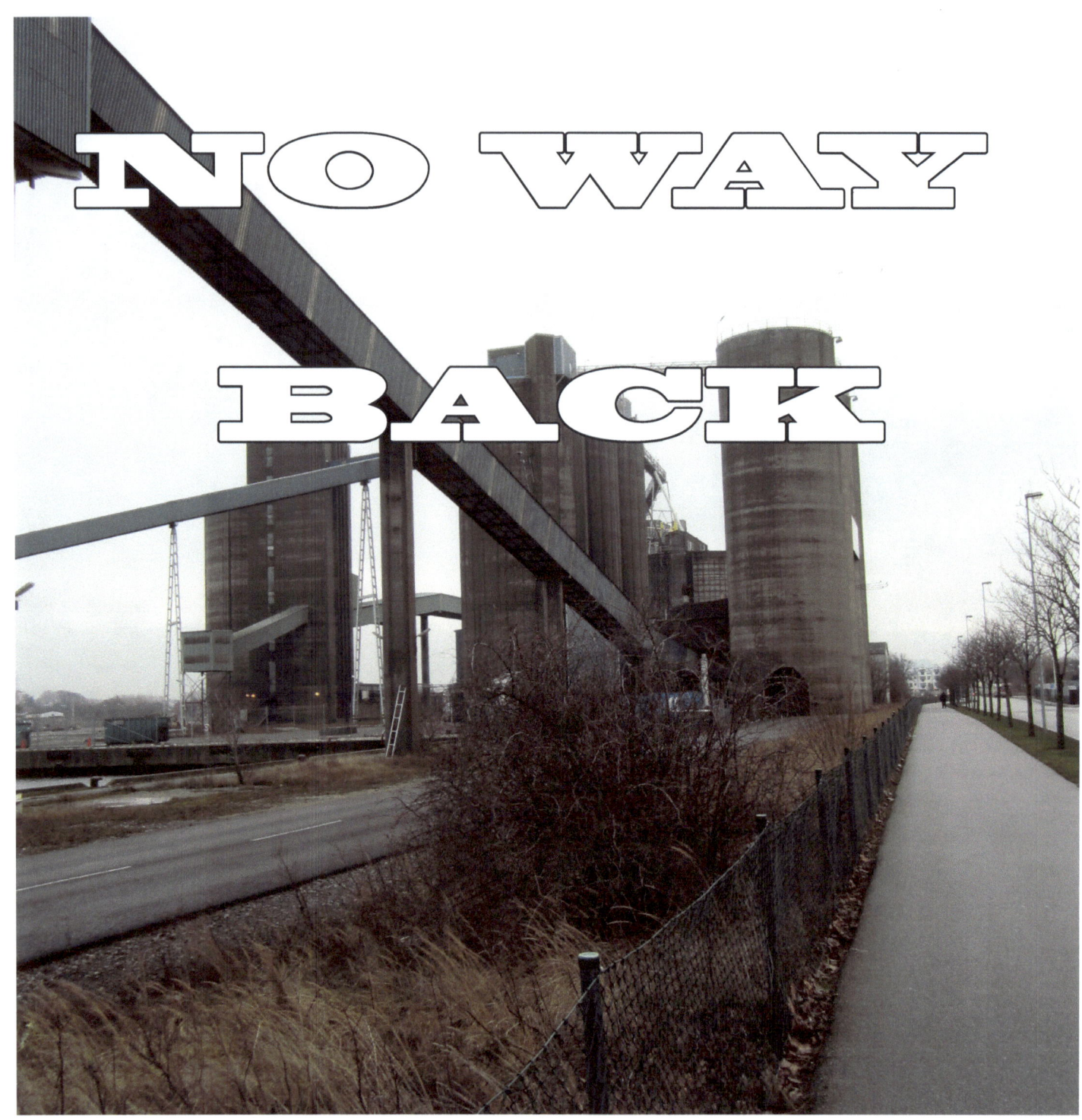

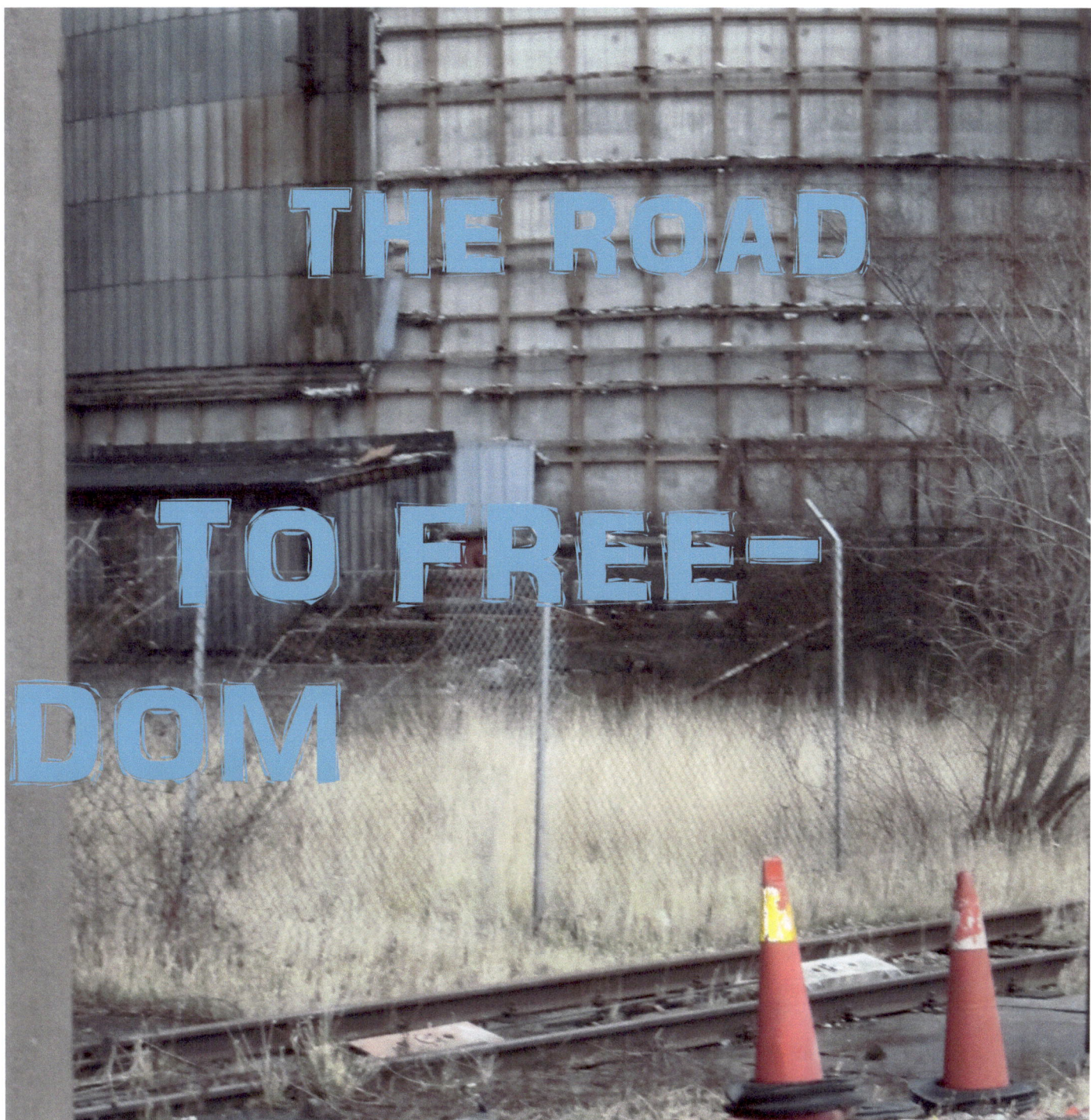

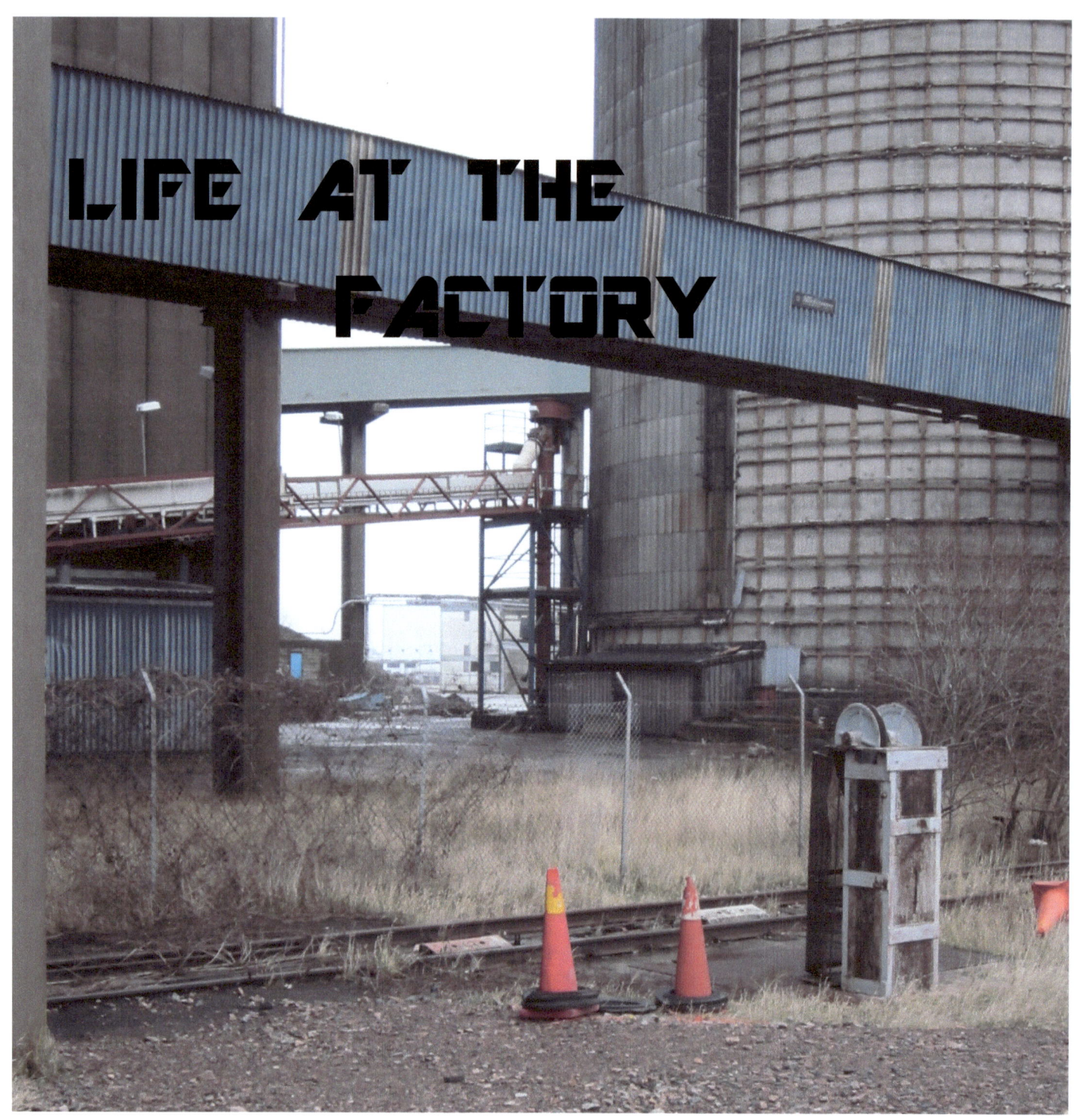

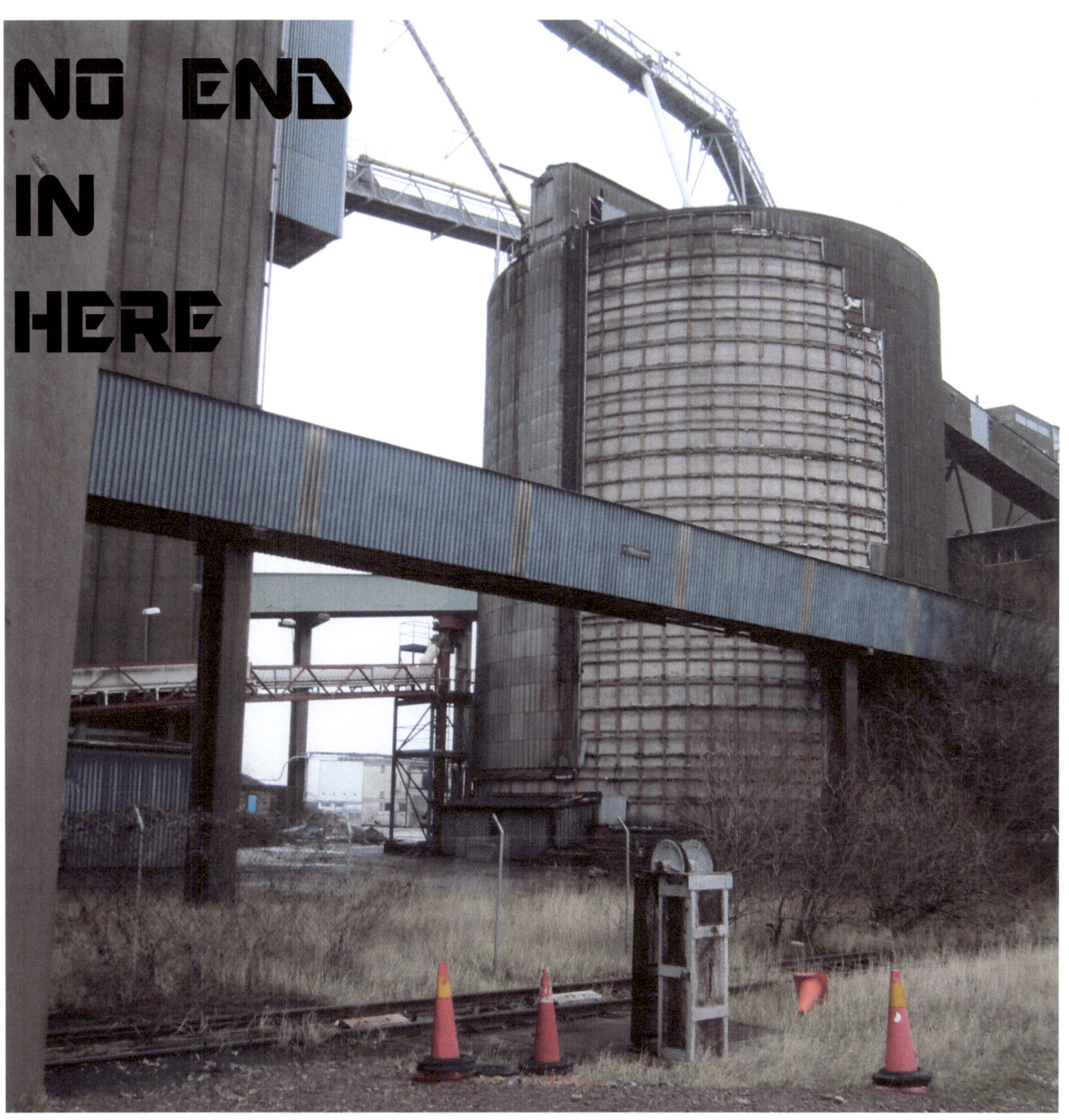

FADING AWAY

THE LIGHT
OUTSIDE

SEES
EVERYTHING

DANGER FROM FAR

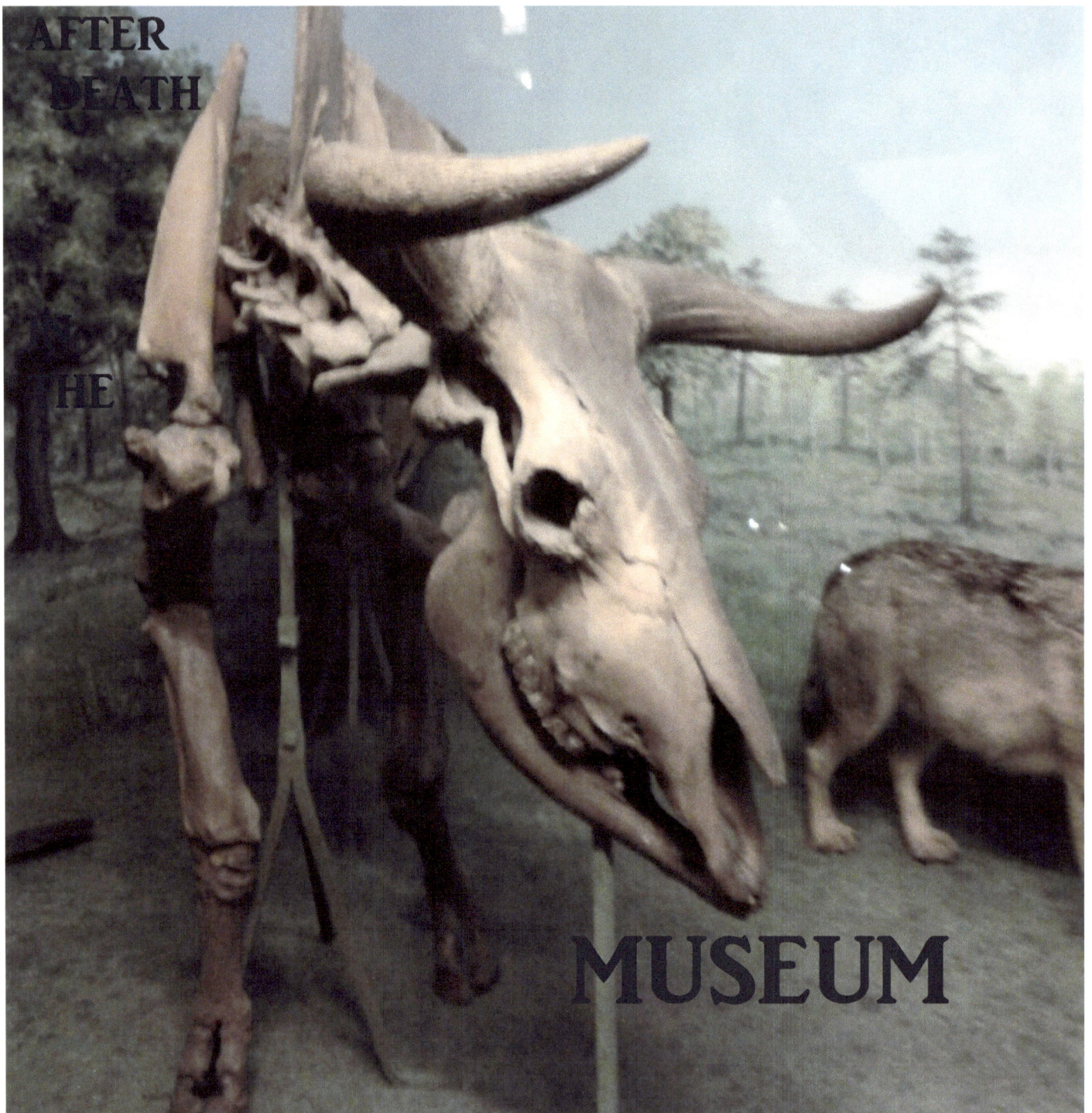

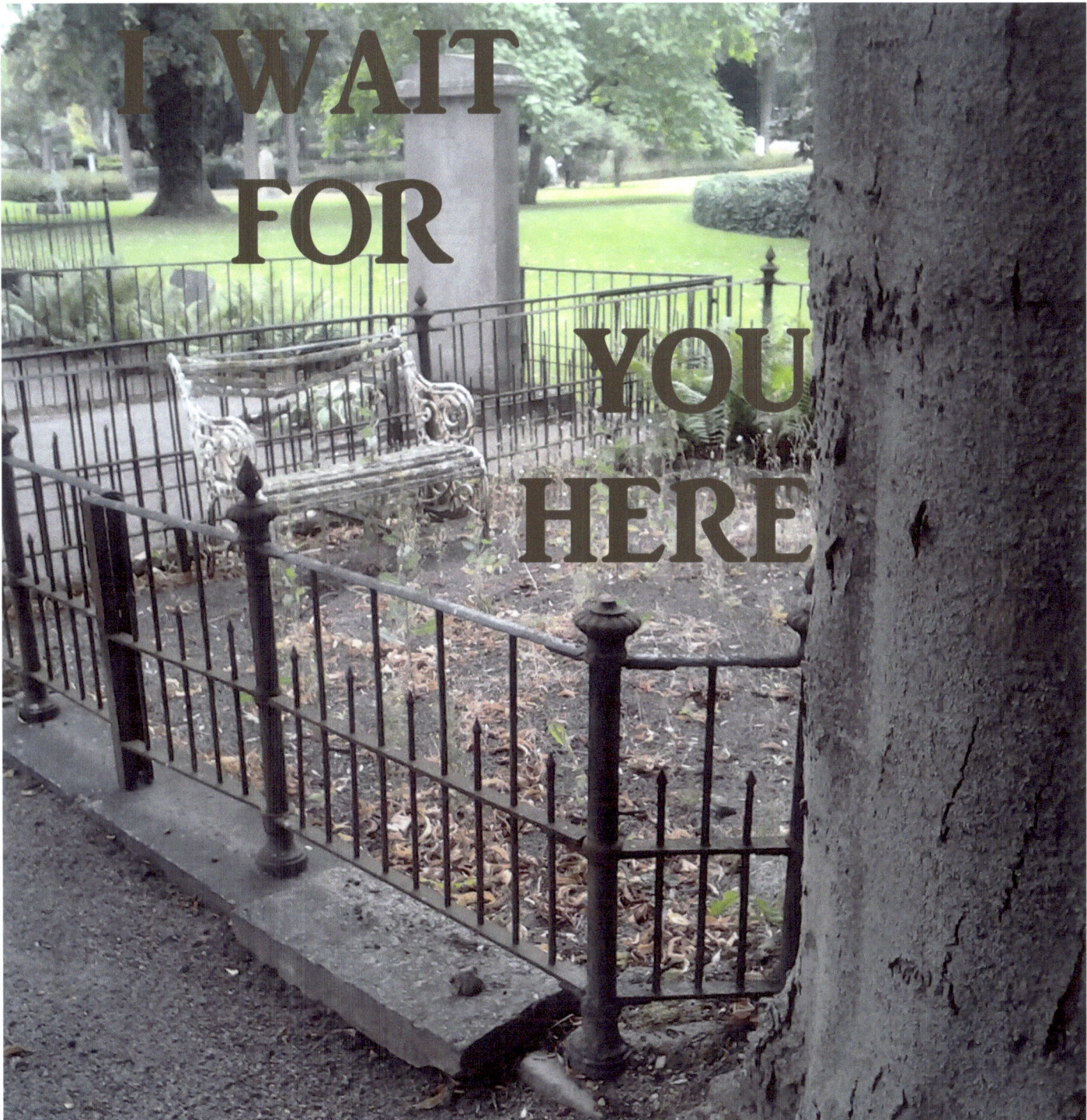

LIGHT AT NIGHT

THE LAST GLASS BEFORE CLOSING

SAFE

DANGER

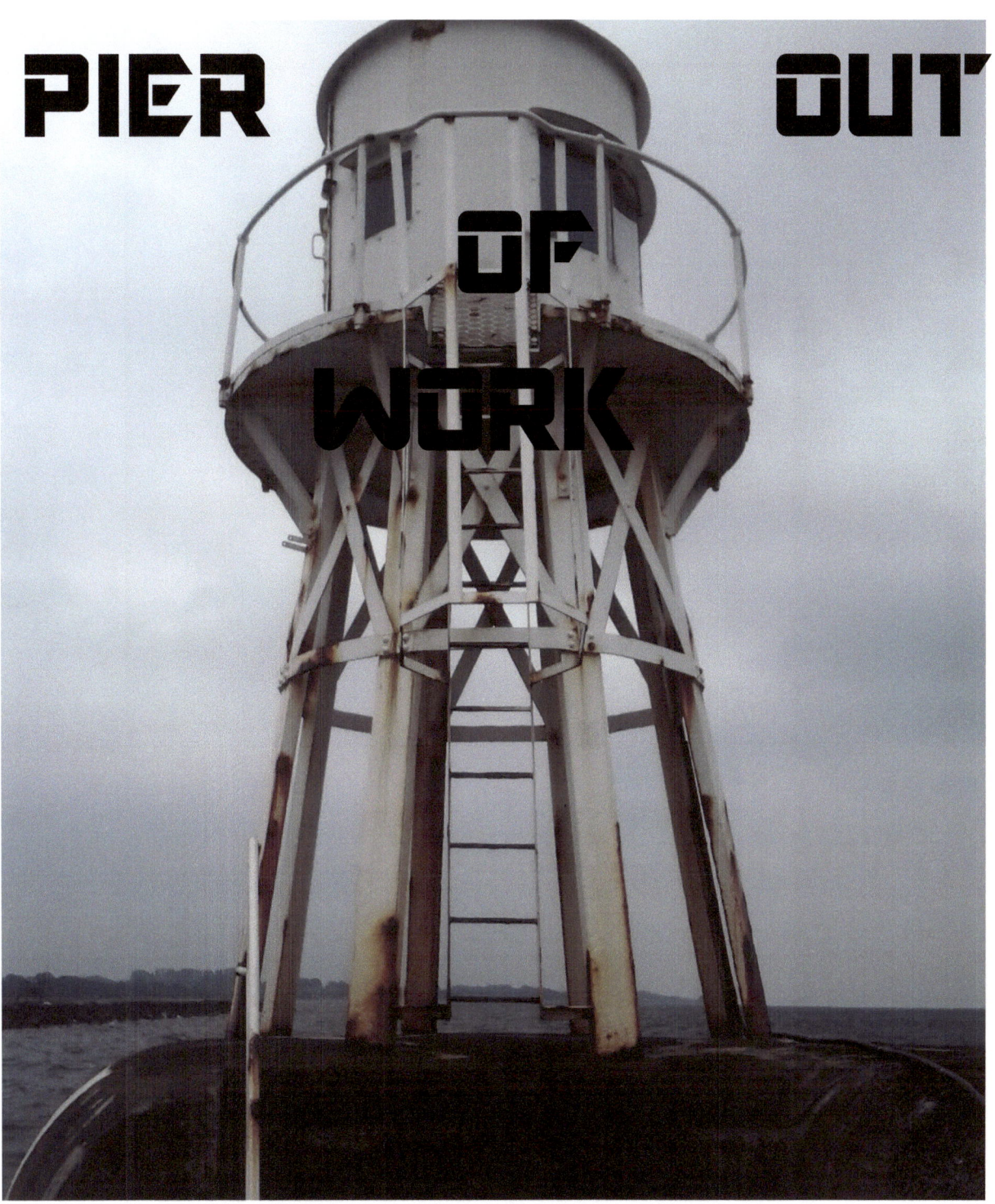

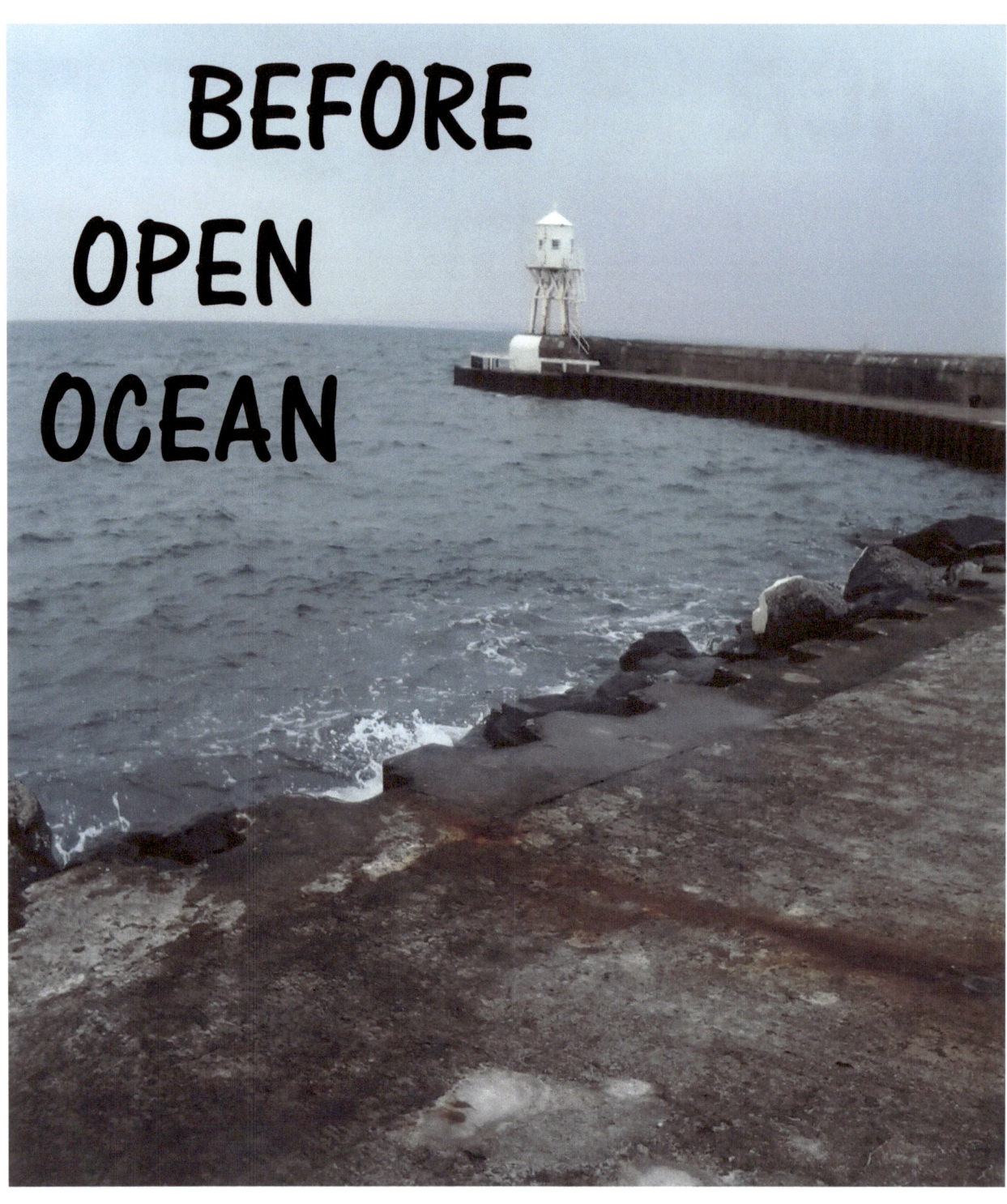

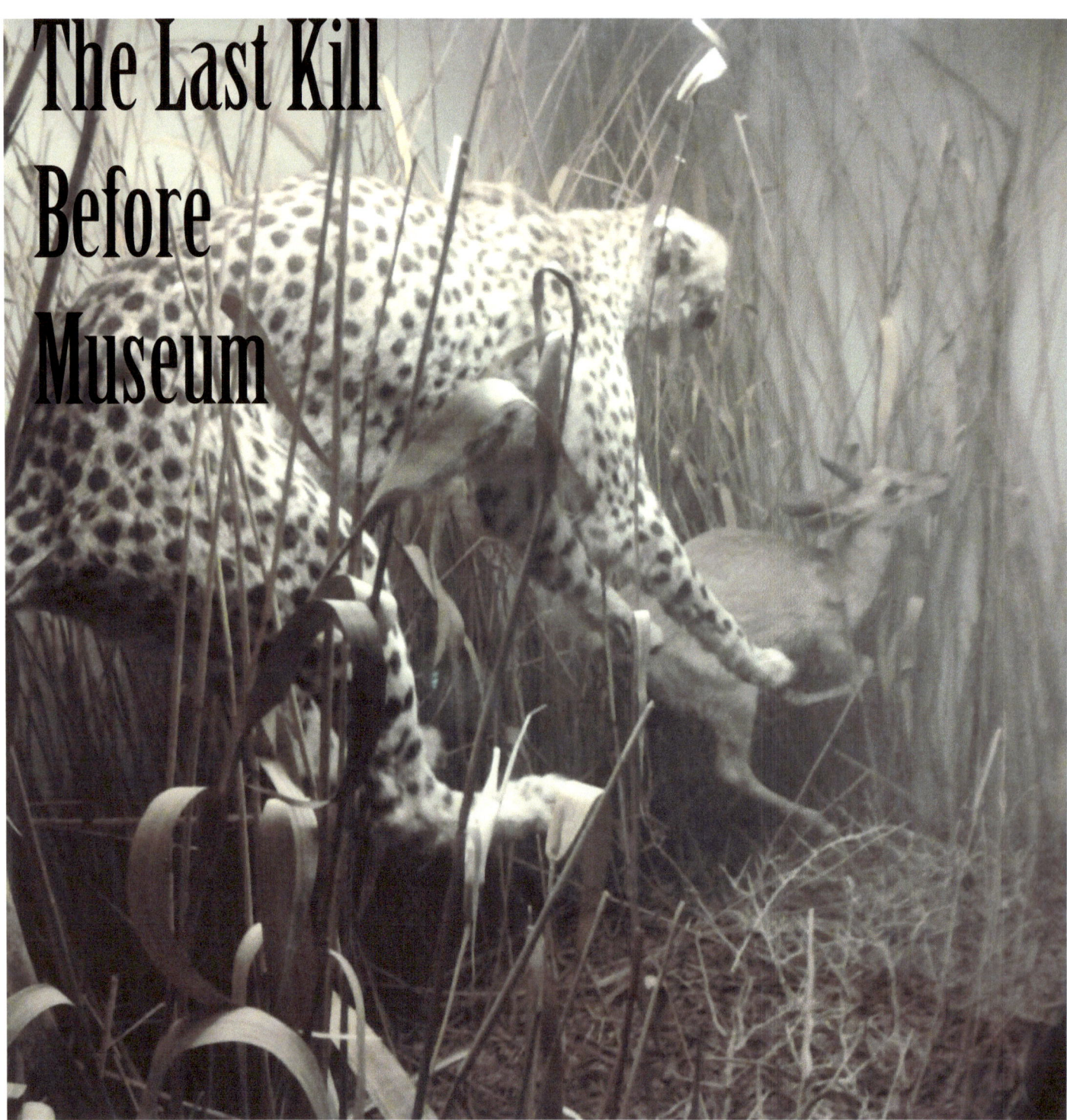
The Last Kill Before Museum

www.ingramcontent.com/pod-product-compliance
Lightning Source LLC
Chambersburg PA
CBHW050414180526
45159CB00005B/2274